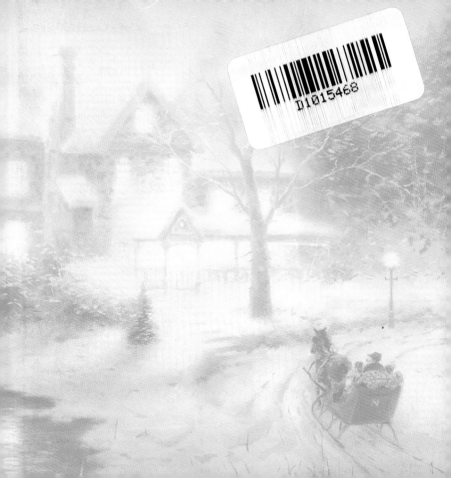

THOMAS KINKADE

The Light of Christmas

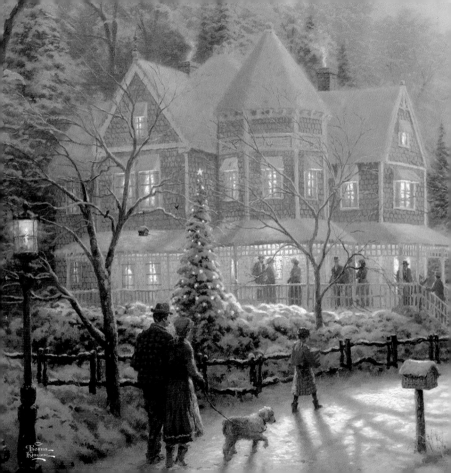

THOMAS KINKADE

The Light of Christmas

For information, write Andrews McMeel Publishing, an Andrews McMeel Universal company, 4520 Main Street, Kansas City, Missouri 64111.

ISBN: 0-7407-2705-2
Library of Congress Catalog Card Number: 20021002585

Compiled by Patrick Regan

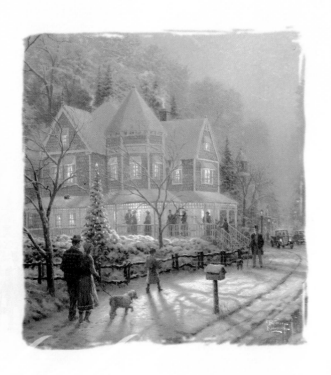

*Remembrance, like a candle,
burns brightest at Christmastime.*

—Charles Dickens

No holiday has the power to captivate our senses or dominate our memories quite like Christmas. The sights, smells, and sounds of Christmas are burned into our consciousness in childhood, and with each passing year, another layer of joyous memories is added.

The smell of fresh-baked holiday treats and freshly cut pine boughs; the merry, riotous sound of children giggling with anticipation and screaming with delight; the sight of holiday lights on a new-fallen snow or the warm glow of

firelight cast from a room where family and dear friends gather—all of these images delight our senses and fill our memories. Christmas is a day—and a season—like no other.

I hope this collection of paintings and quotations from the season helps inspire your own fond memories of Christmas just as it has my own.

Have a Merry Christmas and a Blessed New Year,

Thomas Kinkade

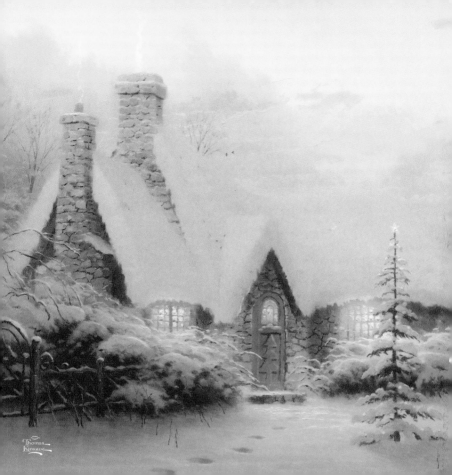

Christmas is here,

Merry old Christmas,

Gift-bearing Christmas,

Day of grand memories,

King of the year!

—Washington Irving

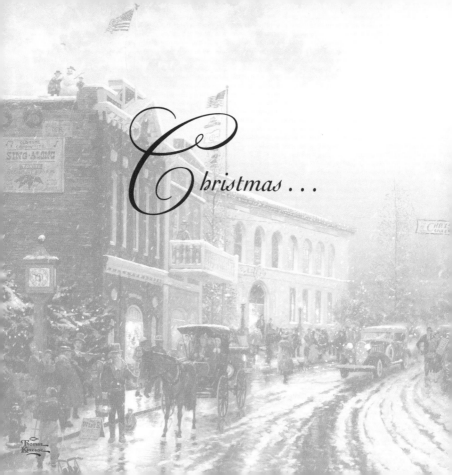

Christmas . . .

eart

is not an external event at all

but a piece of one's home that

one carries in one's heart.

—Freya Stark

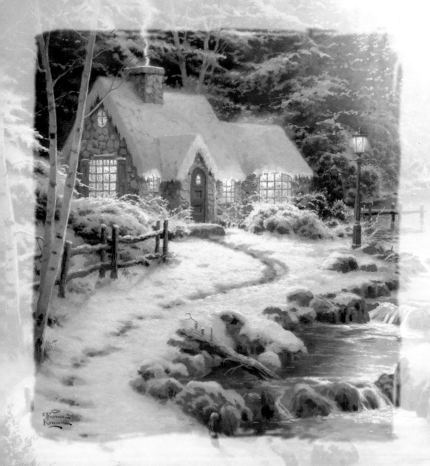

Where we love is home—

home that our feet may leave,

but not our hearts.

—Oliver Wendell Holmes

Christmas Eve
was a night of song
that wrapped itself about you
like a shawl.
But it warmed more
than your body.
It warmed your heart . . .
filled it, too,
with melody that would last
forever.

—Bess Streeter Aldrich

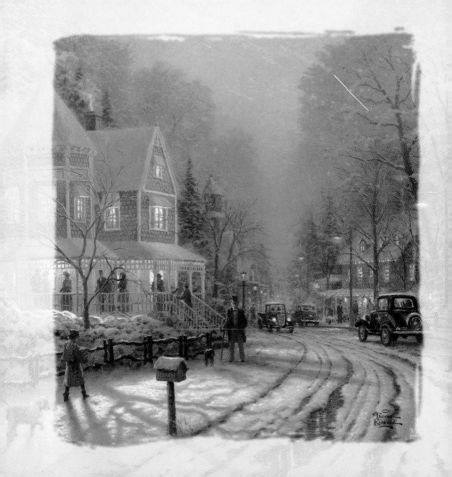

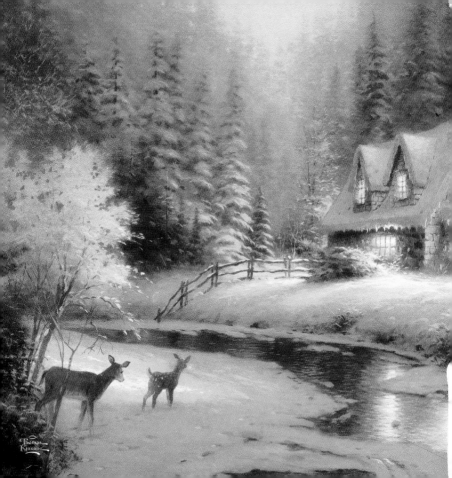

Happy, happy Christmas, that can win us back to the delusions of our childhood days, recall to the old man the pleasures of his youth, and transport the traveler back to his own fireside and quiet home!

—Charles Dickens

Tradition

does not mean

that the living are dead

but that the dead are living.

—G. K. Chestertson

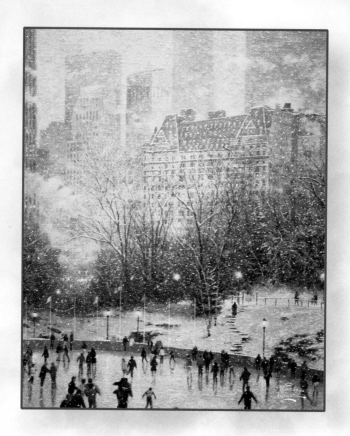

Recall it as often

as you wish;

a happy memory

never wears out.

—Libbie Fudim

memories

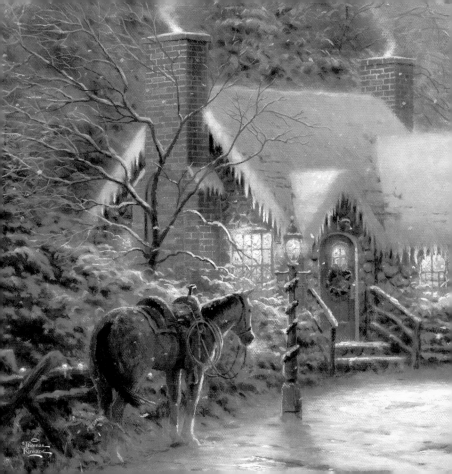

Blessed is the season

which engages

the whole world

in a conspiracy

of love.

—Hamilton Wright Mabie

*A holiday gives one a chance
to look backward and forward,
to reset oneself
by an inner compass.*

—May Sarton

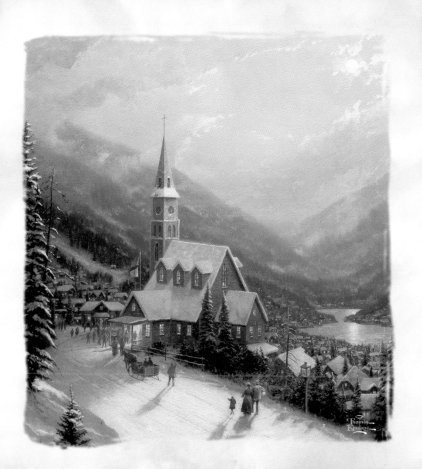

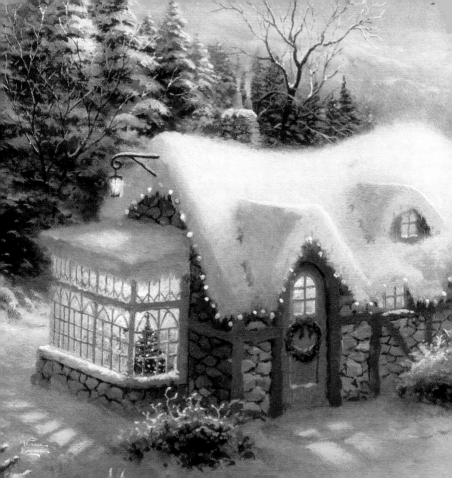

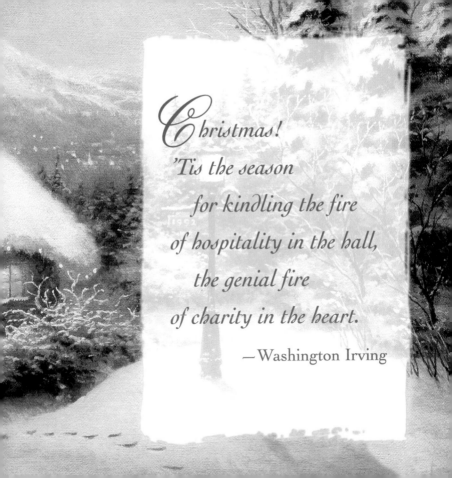

Christmas!
'Tis the season
for kindling the fire
of hospitality in the hall,
the genial fire
of charity in the heart.

—Washington Irving

Heap on more wood! —
the wind is chill;
But let it whistle
as it will,
We'll keep our Christmas
merry still.

—Sir Walter Scott

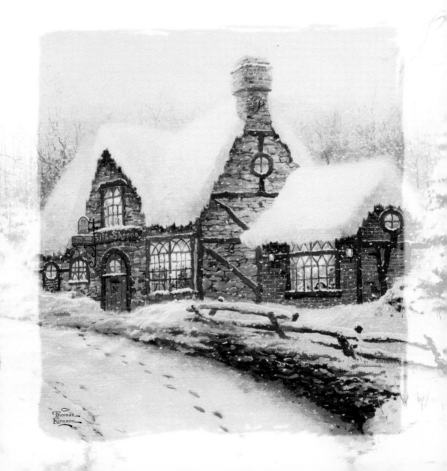

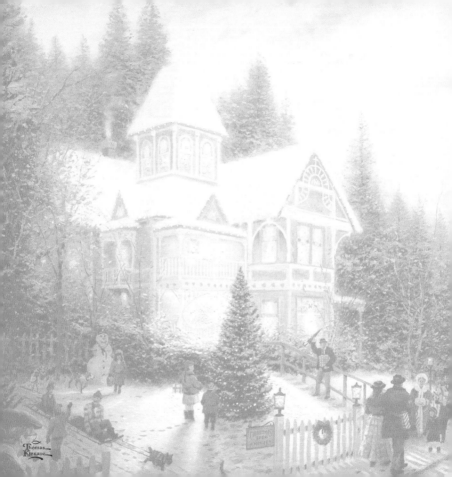

Christmas, children,

is not a date.

It is a state of mind.

—Mary Ellen Chase

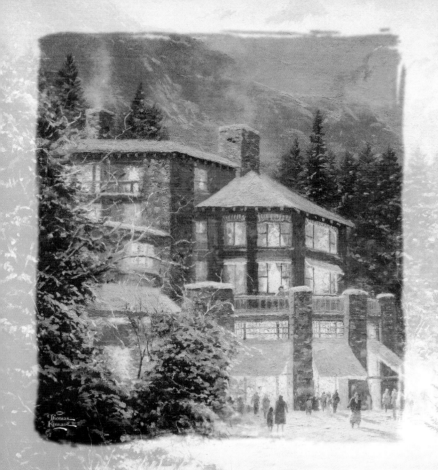

At Christmas play
and make good cheer,
For Christmas comes
but once a year.

—Thomas Tusser

O sons of the morning,

rejoice at the sight.

Everywhere, everywhere,

Christmas tonight!

—Phillips Brooks

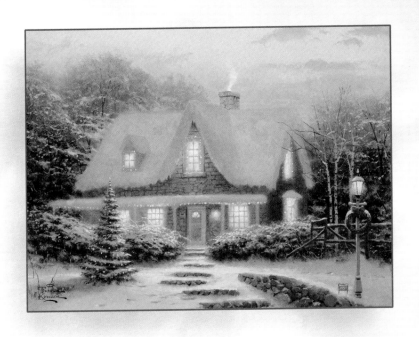

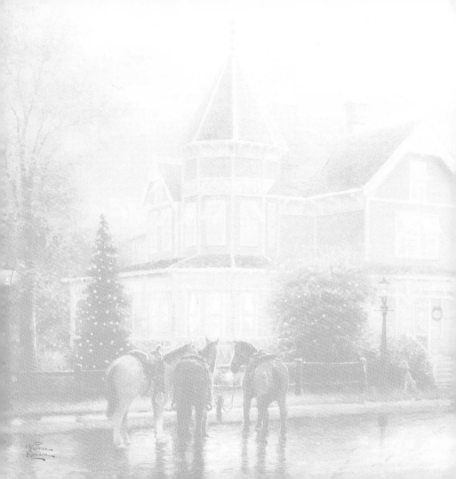

Villagers all, this frosty tide,

Let your doors

swing open wide,

Though wind may follow,

and snow beside,

Yet draw us in by your fire to bide;

Joy shall be yours

in the morning!

—Kenneth Grahame

For somehow,

not only at Christmas,

But all the long year through,

The joy that you give to others

Is the joy

that comes back to you.

—John Greenleaf Whittier

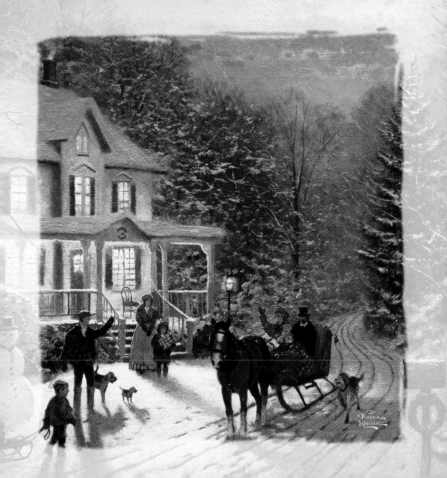

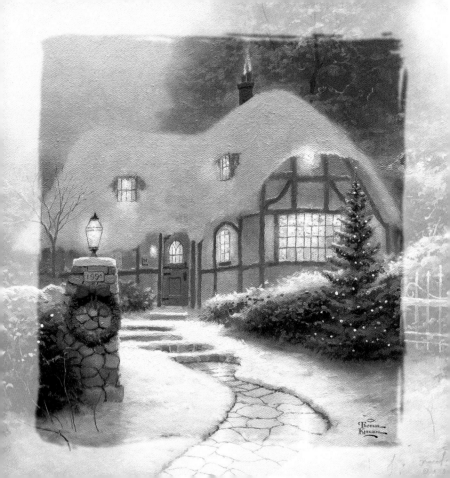

At Christmas

I no more desire a rose

Than wish a snow

in May's newfangled mirth;

But like of each thing

that in season grows.

—William Shakespeare

I heard the bells
 on Christmas Day
Their old, familiar
 carols play,
And wild and sweet
The words repeat
Of peace on earth,
 goodwill to men!

—Henry Wadsworth Longfellow

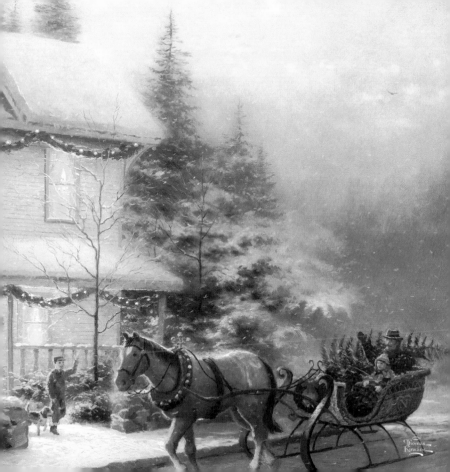

Thomas Kinkade

*S*mall cheer

and great welcome

makes a merry feast.

—William Shakespeare

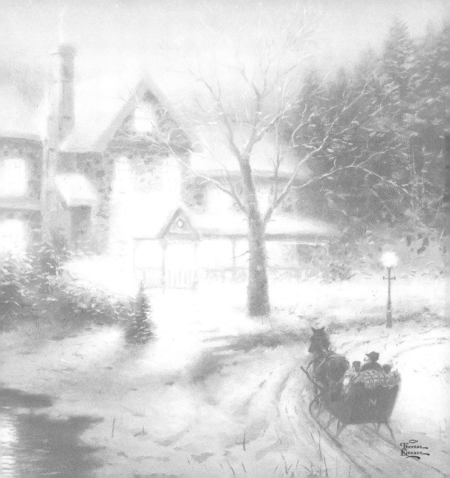

Thomas Kinkade

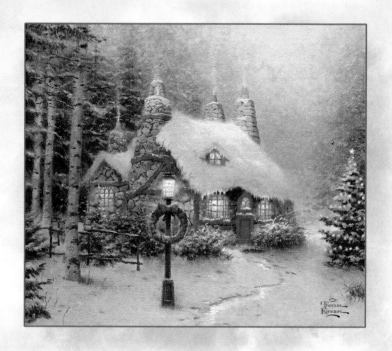

For not alone

at Christmastime

comes holiday and cheer,

For one who loves a little child

has Christmas all the year.

—Florence Evelyn Dratt

Joy is not in things,
it is in us.

—Benjamin Franklin

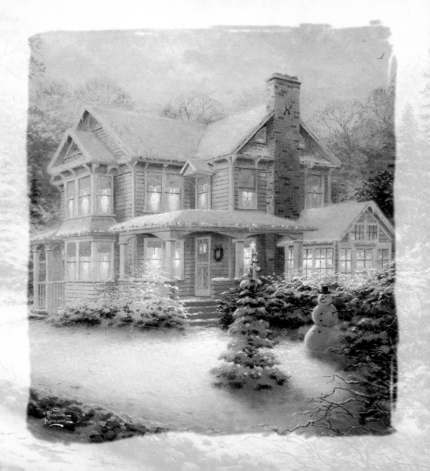

Most all the time,

the whole year round,

there ain't no flies on me,

But jest 'fore Christmas

I'm as good as I kin be!

—Eugene Field

remembrance

Remembrance,

like a candle,

burns brightest

at Christmastime.

—Charles Dickens

like a candle

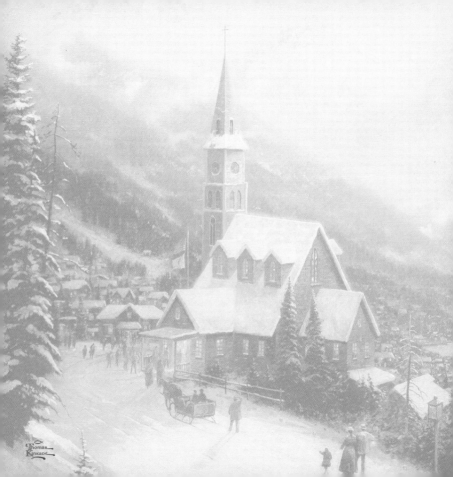

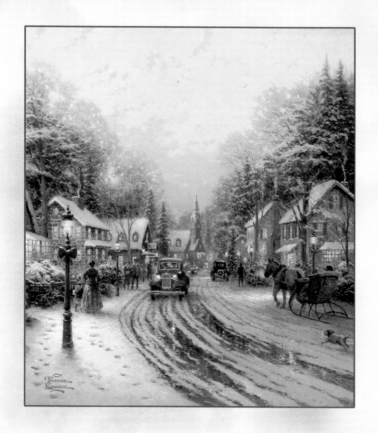

The time draws near
the birth of Christ:
The moon is hid;
the night is still;
The Christmas bells
from hill to hill
Answer each other in the mist.

—Alfred, Lord Tennyson

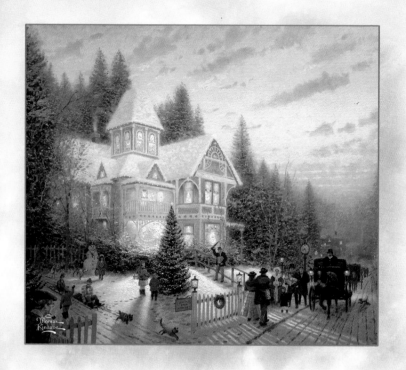

merry

The guests are met,

the feast is set:

May'st hear the merry din.

—Samuel Taylor Coleridge

guests

Over the river

and through the woods,

Trot fast my dapple gray;

Spring o'er the ground

just like a hound,

For this is Christmas Day.

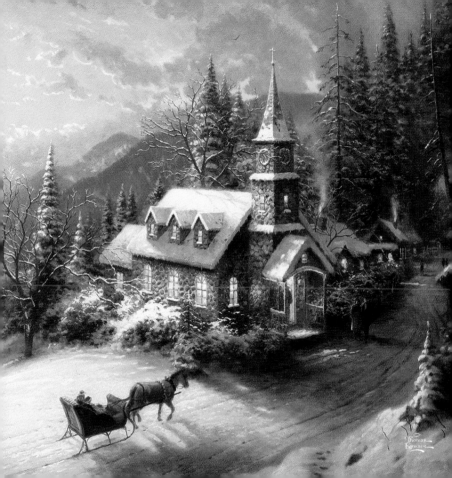

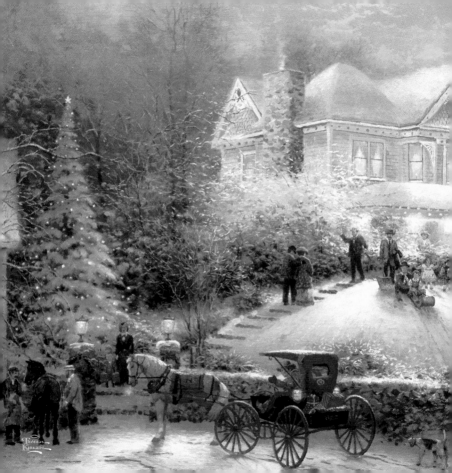

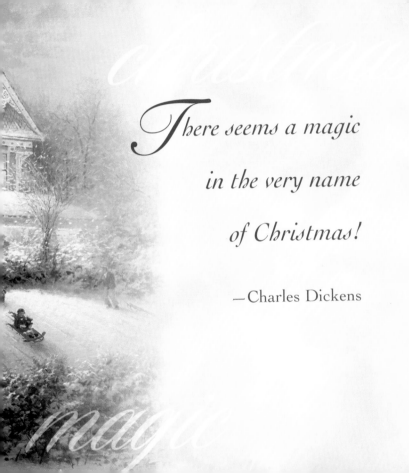

There seems a magic

in the very name

of Christmas!

—Charles Dickens

If you have much,

give of your wealth;

If you have little,

give of your heart.

—proverb

giving

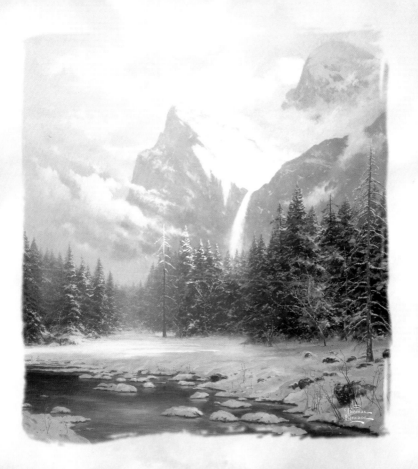

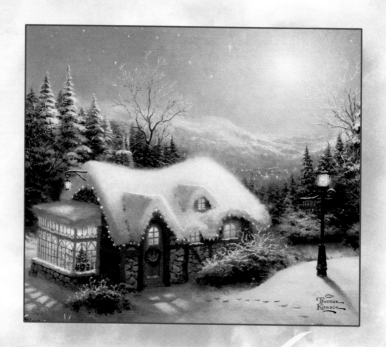

May you have
the gladness of Christmas
which is hope;
The spirit of Christmas
which is peace;
The heart of Christmas
which is love.

—Ada V. Hendricks

*Call a truce,
then, to our labors —
let us feast
with friends
and neighbors.*

—Rudyard Kipling

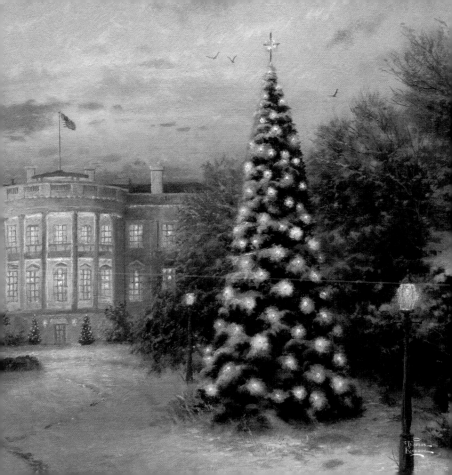

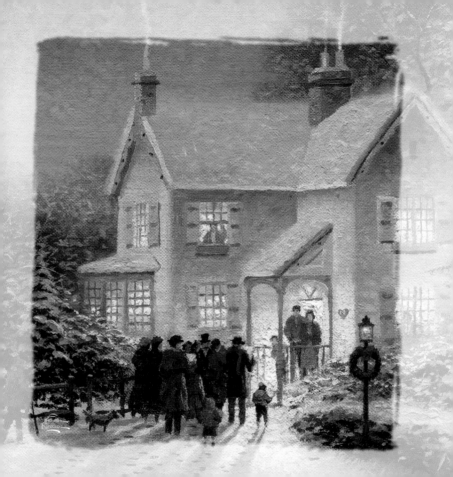

We shall find peace.

We shall hear angels,

we shall see the sky

sparkling with diamonds.

—Anton Chekhov

Through the years

we all will be together

If the Fates allow

Hang a shining star

upon the highest bough.

And have yourself

a merry little Christmas now.

— Ralph Blane

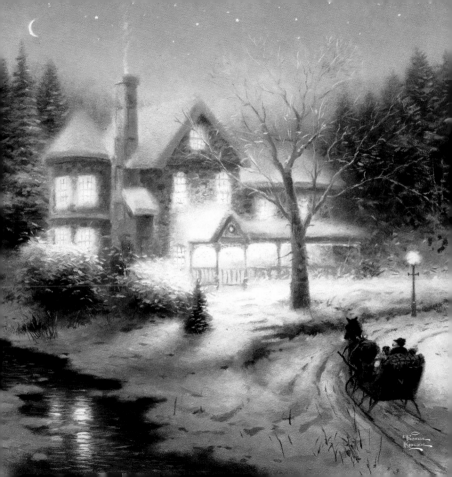

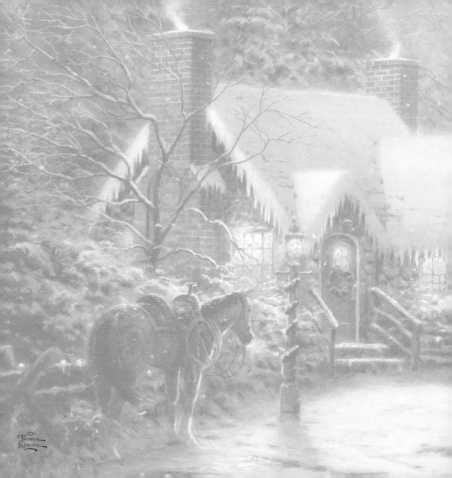

Let Us Keep Christmas

Whatever else be lost among the years,

Let us keep Christmas

 still a shining thing;

Whatever doubts assail us, or what fears,

Let us hold close one day, remembering

Its poignant meaning

 for the hearts of men.

Let us get back our childlike faith again.

—Grace Noll Crowell

There is a better thing

than the observance

of Christmas day,

and that is,

keeping Christmas.

—Henry Van Dyke

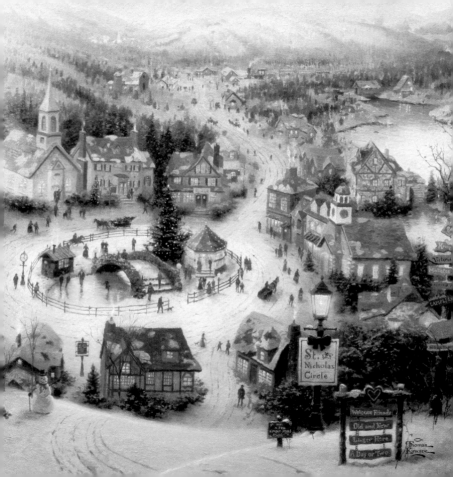

St. Nicholas Circle

Welcome Friends
Old and New
Linger Here
A Day or Two

Thomas Kinkade

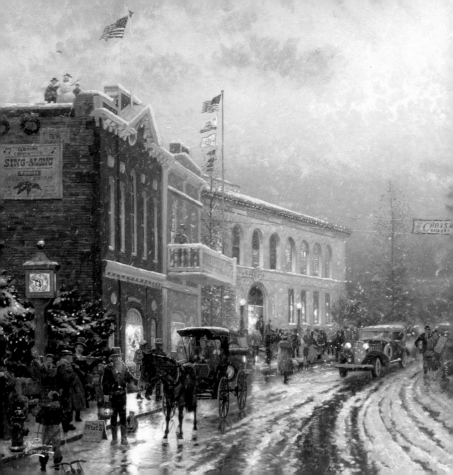

Holly and Holiness
Come well together;
Christ-Child and Santa Claus
Share the white weather;
Plums in plum pudding and
Turkey with dressing,
Choirs singing Carols —
All have his blessing.

—Ralph W. Seager

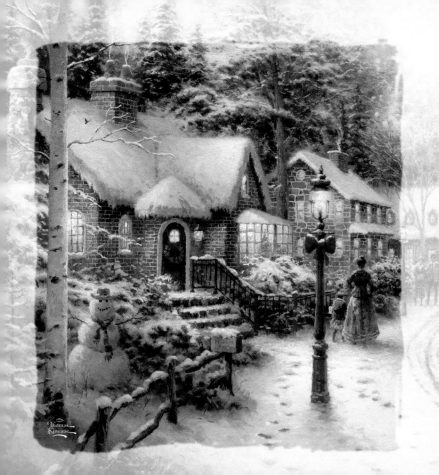

He that is of a merry heart

hath a continual feast.

—Proverbs 15:15

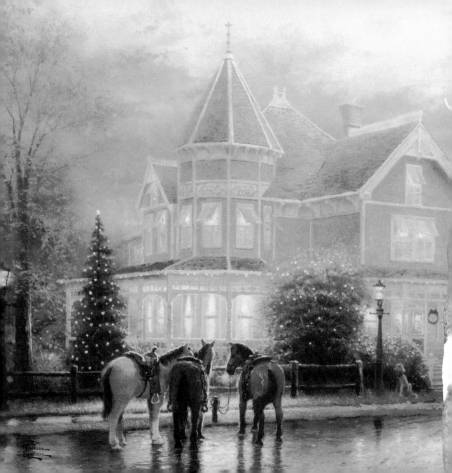

And, through

and over everything,

A sense of glad awakening.

—Edna St. Vincent Millay

The holly's up,
* the house is all bright,*
The tree is ready,
* the candles alight:*
Rejoice and be glad,
* all children tonight!*

—Peter Cornelius

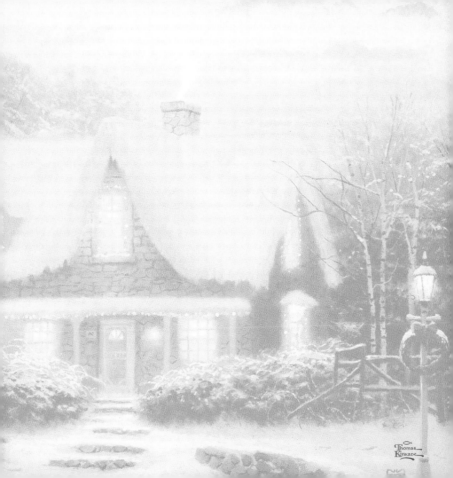

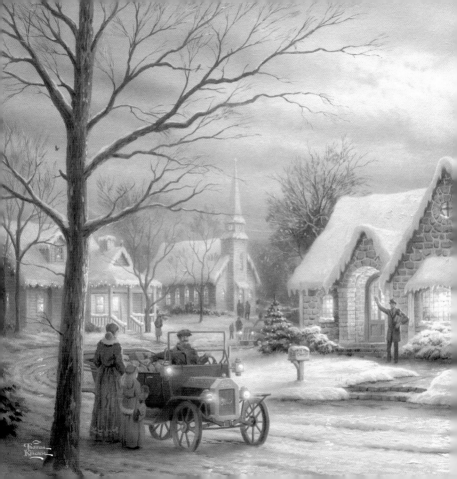

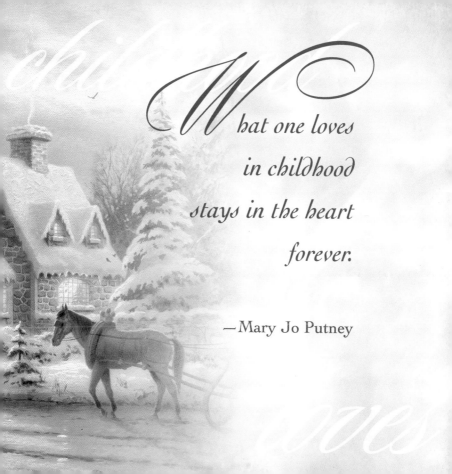

What one loves
in childhood
stays in the heart
forever.

—Mary Jo Putney

There are no seven wonders of the world in the eyes of a child. There are seven million.

—Walt Streightiff

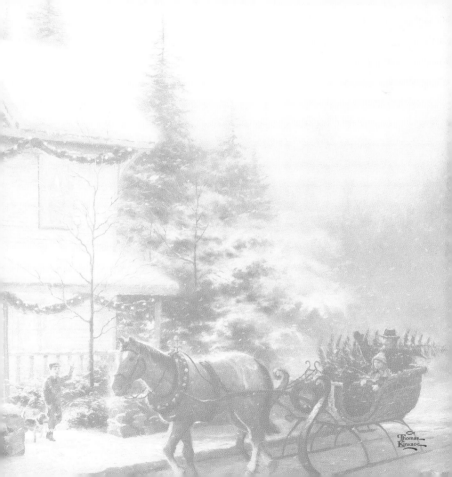

The best things you can give children, next to good habits, are good memories.

—Sydney J. Harris

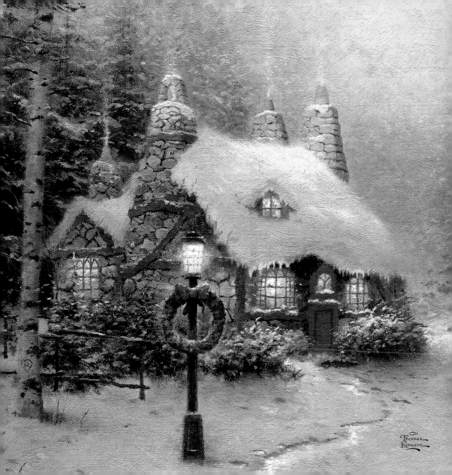

For we need a little music,
Need a little laughter,
Need a little singing
Ringing through the rafter,
And we need a little snappy
"Happy ever after,"
We need a little Christmas now.

—Jerry Herman

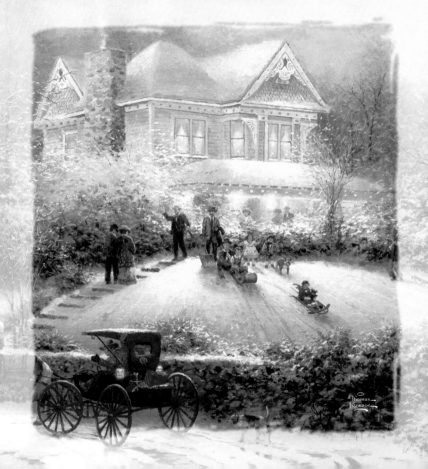

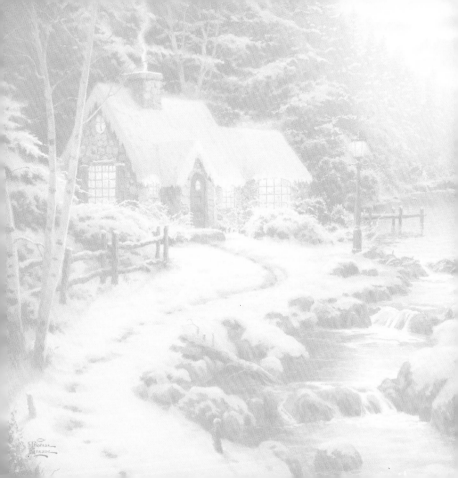

Fir balsam is like no other cargo;
even a workaday truck is exalted
and wears a consecrated look when
carrying these aromatic dumplings
to the hungry dwellers in cities.

—E. B. White

My white spruce tree, one of the

small ones in the swamp . . .

looked double its size

It was lit with candles,

but the starlit sky

is far more splendid tonight.

—Henry David Thoreau